colormorphia

A **PLUME** BOOK

Color, Morph, Create

Welcome to my high-definition, super-detailed doodle world, where striking animals morph into strange beings, objects explode into flowers, and dreamscapes become reality.

In this celebration of coloring, you'll find a selection of images that have been completed by some super-talented colorists. Discover their palette choices, blending techniques, additions, and innovations. Read my impressions of each piece and what I think makes them work so well. Gather inspiration so you can explore your own creativity.

These pictures, and a collection of my favorite images from my **morphia** books, appear in the coloring section for you to bring to life.

Make each detailed image your own colorful masterpiece.

Kerby Rosanes

Beetle (previous page) colored by Marcela Lašáková, a.k.a @marcelalasakova
Kong (this page) colored by Sari Hankaniemi, a.k.a @sari_kani_

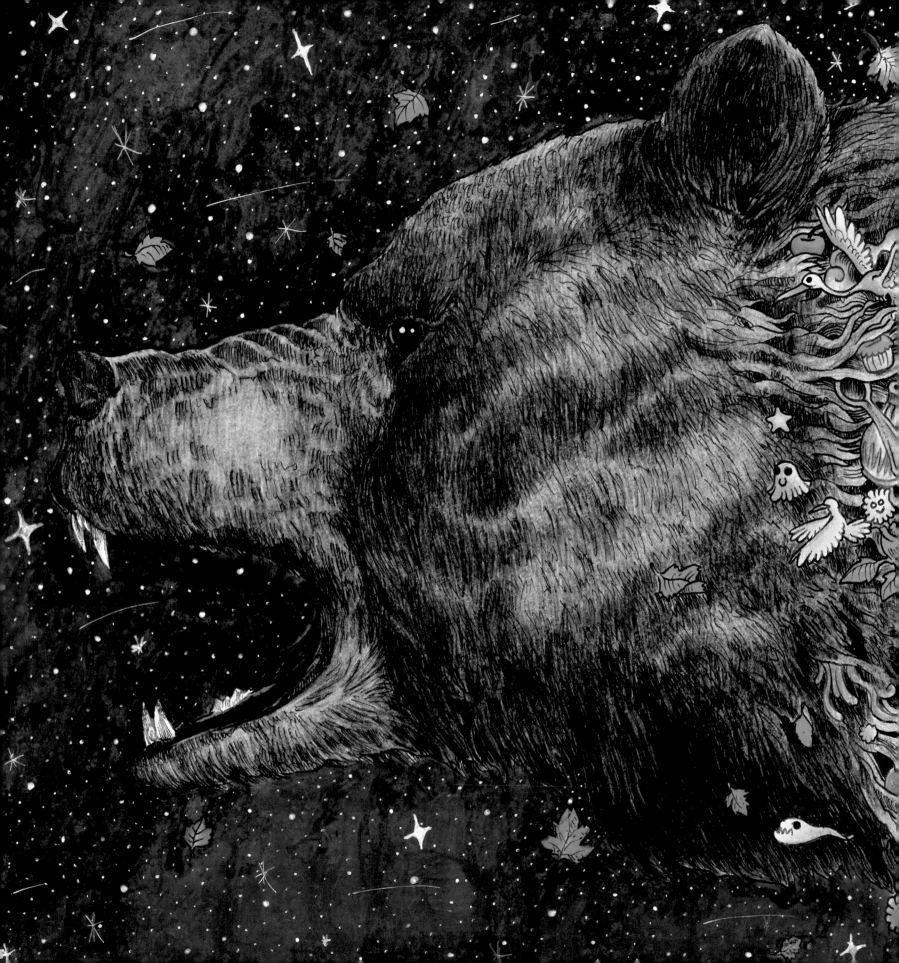

Galactic Bear—Creating Your Own Backgrounds (previous page)
Colored by Sarah, a.k.a @thai.lyss

This image has been colored with great precision using professional, high-quality coloring pencils. Special care has been given to the bear's fur, making sure that it has a realistic shine. A great way to create this effect is to first study some photographs of fur, or look at it in real life. You can examine the texture, the way it falls and how it captures the light. In this image, the ripples of light falling across the bear's head have been colored in a combination of golden and reddish browns, creating a lustrous, silky appearance.

The colorist has also drawn a night-sky background, completely of her own creation, with accents in black and white marker pen. This is an imaginative way to combine coloring with her own drawing skills. The background is awash with starry details and, rather than opting for a solid black background that might flatten the effect of the image, a subtle texture has been added, using rich, dark indigos and blues. Doing so gives the impression of a deep, nebulous sky.

In contrast to these deep blues and the bear's brown fur, the colorist has completed the "alien" characters in hot pinks and burnt oranges. These are playful, bright colors that highlight the quirky, fun nature of the images.

Dark Raven—A Masterclass in Graduated Blending (facing page)
Colored by Marjorie Rappillard, a.k.a @marj.0rie

Using directional blending techniques—graduating from dark edges through to a light center—the colorist has created a sense of depth in this image. She has used this technique in between and on the foliage, creating depth and pockets of illuminated space.

Blending and graduating from dark to lighter tones is achieved using high-quality coloring pencils, layering different shades of color and alternating pressure on the pencil. To create this effect, first decide in which direction you wish your tones to graduate and start at the darkest end. Create very dark areas by using a dark color and pressing firmly on the page. For light areas use a lighter shade of pencil and press gently. This colorist has chosen shades of blue and purple as her main color themes, with pops of brighter pinks and oranges to contrast.

To create a seamless effect, from dark to light, gradually layer and overlap each new shade, paying attention to where the shades meet. You can use a colorless blending pencil, or rub some paper towel over the top, to help bleed the colors into one another.

In this image, notice how the colorist has placed dark areas next to light ones. This ensures no element of the detail gets lost—dark purple and hot pink leaves sit on top of pale blue backgrounds. The outer edges of each leaf are deliberately colored dark or pale to stand out against the surrounding areas. These techniques serve to draw the eye into the glowing focal point of the picture—the fiery orange eye and beak of the raven.

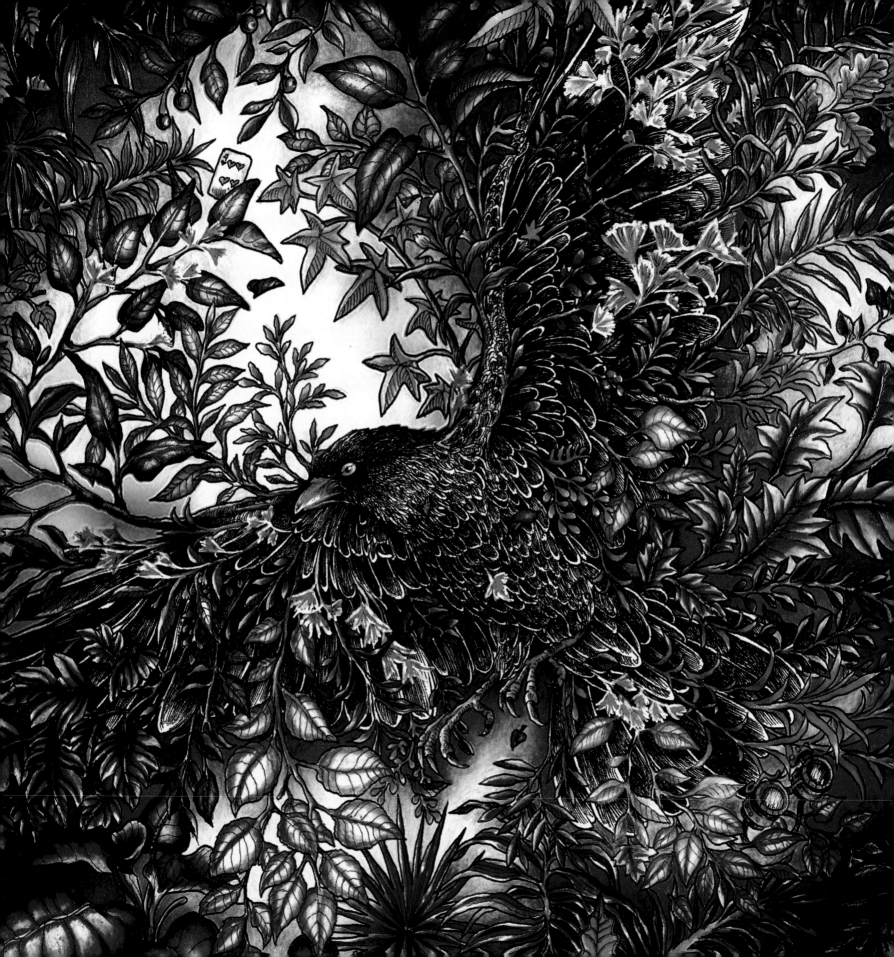

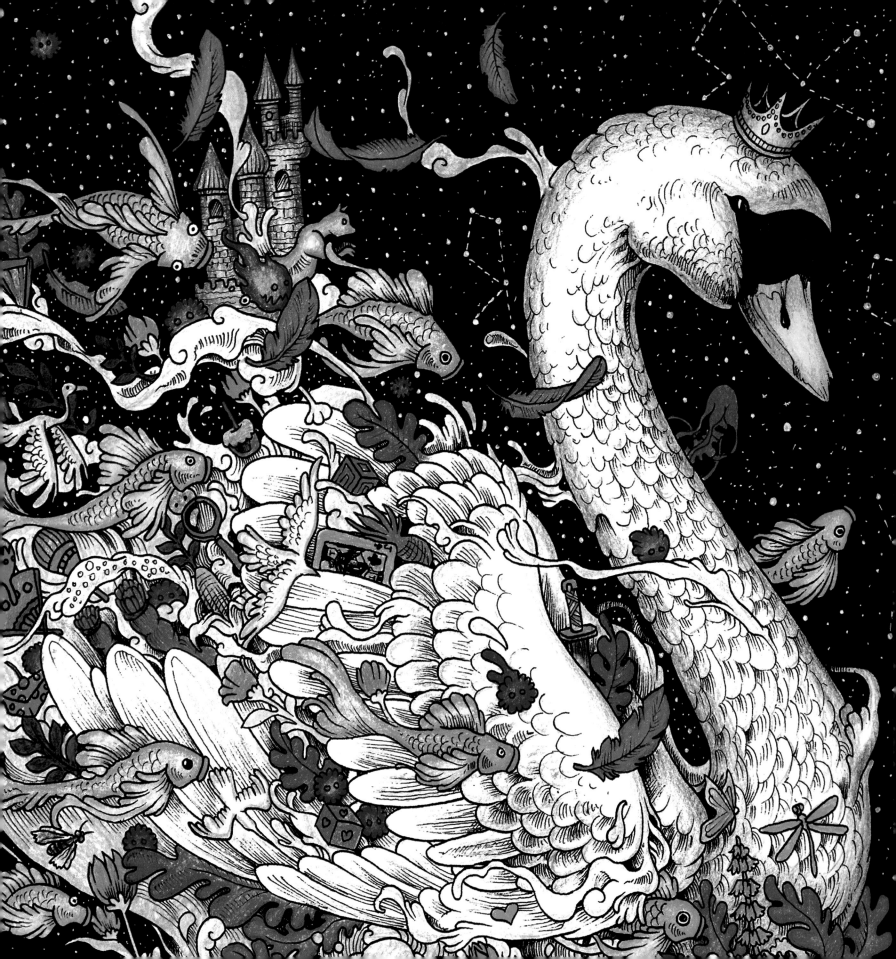

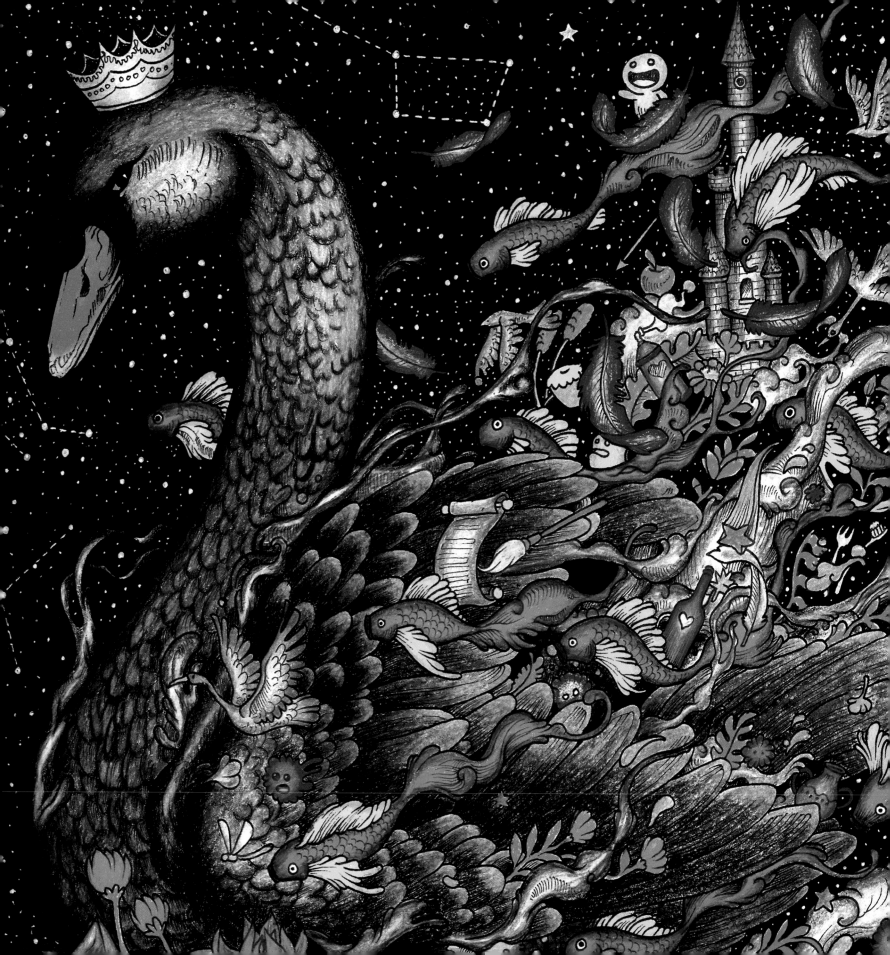

Swan Reflection—**Building a Narrative (previous page)**
Colored by Magdalena Cieślak, a.k.a @_rosecoloredgirl

This colorist has not only completed this image with skill, even down to the detail of adding real star constellations to the night-sky background using a white gel pen, she has also given a lot of thought to imbuing the picture with meaning.

The colors that have been selected for the two halves of the image have created a narrative. By contrasting a white swan with a black swan, the colorist is perhaps recalling the two opposing swans in the ballet *Swan Lake*. Whatever the inspiration, the contrast creates a striking day-and-night effect.

The light and dark is emphasized by the colors chosen for each of the character details—the white swan is accompanied by warm peachy-pinks, magentas, and violets, whereas the black swan is surrounded by more mysterious cobalt blues and turquoises. The colorist has used soft core pencils, which are ideal for layering and blending colors. When deciding on colors for your own artworks it can help to think about what meaning they might give to the images, how they can change the feel and atmosphere and even give the subjects their own personalities.

Egyptian Explosion—**Combining Traditional and Digital Techniques (facing page)**
Colored by Xenia Morozova, a.k.a @1980kxenia

Xenia's Tutankhamun image takes coloring to another level. She has skillfully combined traditional hand coloring with digital effects. With hand coloring she has created a "high-shine" effect on the mask of Tutankhamun, using sharp, high-contrast coloring. Note the curved shine around the headdress of the mask, and the way the light and dark shade into each other, almost not blending at all. This gives the impression of a highly polished, metallic finish with extreme 3-D depth.

The background of the image has been completed with digital coloring. If you have access to a digital coloring program, such as Photoshop, and a scanner to upload a colored image to a computer, the sky is the limit with the effects you can create. You also don't have to worry about making mistakes—just delete them with the click of a button.

Here, the colorist has layered dream-like colors, such as magentas, sea greens, and periwinkle blues, with a soft-edged digital coloring brush. She has also added glowing white fantastical details, patterns, and hieroglyphs to the background—something that would be difficult to achieve with traditional methods.

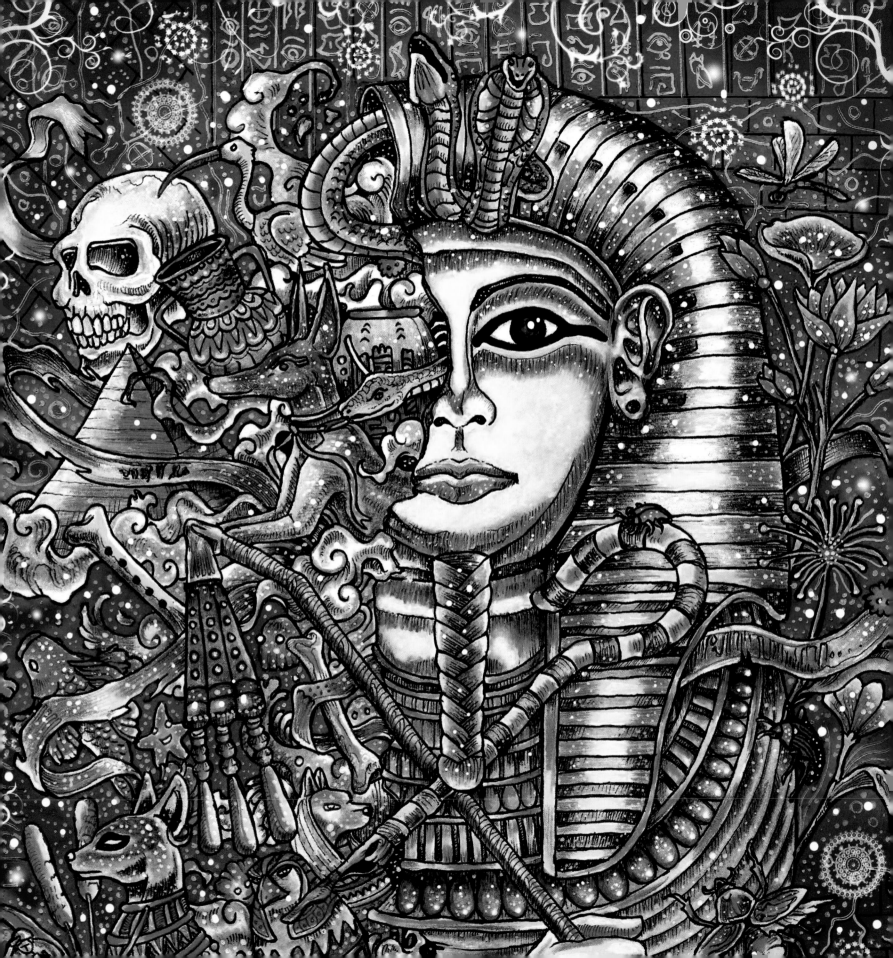

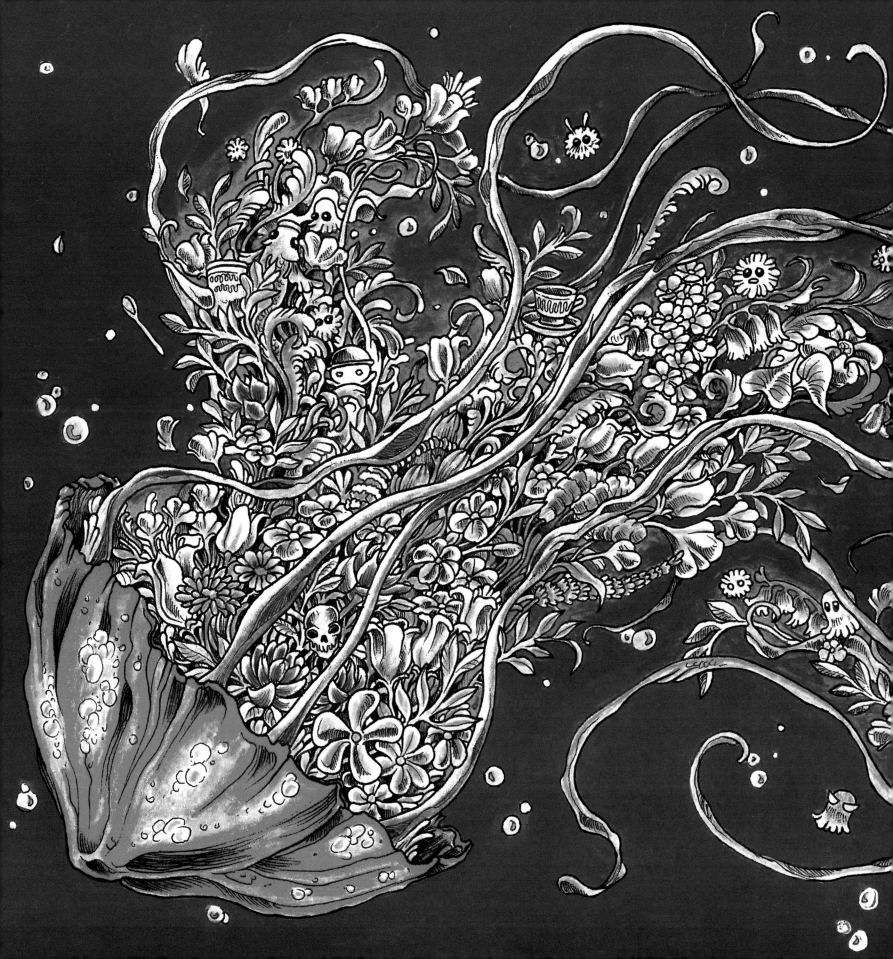

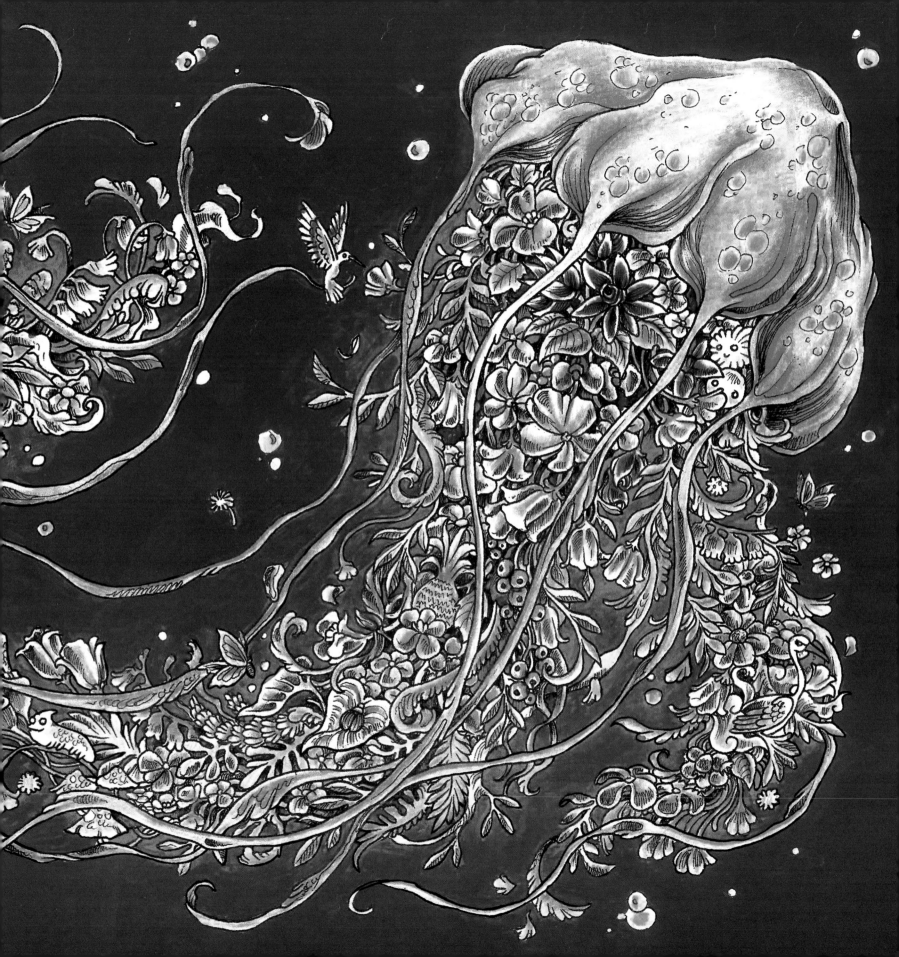

Jewel-like Jellyfish—A Feast for the Eyes (previous page)
Colored by Natalia Filippova, a.k.a @natali78art

In this image the colorist has used a wealth of colors. There are turquoises and cobalt blues, hot and powder pinks, lime and forest greens, peaches, violets, and magentas. It's a jewelery box of shades, which encourages the eye to dance around, absorbing each delicate detail.

The fragility of each petal and leaf has been highlighted with color, graduating from strong to pale tones. The blue of the background has also been graduated, shifting from a dense block of dark blue to a lighter blue in the areas surrounding the tentacles and flowers. This creates areas of illuminated space, making the jellyfish and flowers stand out. It gives each of the jellyfish a milky glow. All the shades in the image combine to create something finely balanced and almost ethereal.

Flowering Skull—Colors That Glow (facing page)
Colored by Lisa Brothwood, a.k.a @lb.indigo

Much like the actual subject of the image—a grinning skull juxtaposed with delicate florals and detailed patterns—the colorist has employed two opposing coloring techniques in this piece. In this take on a Mexican sugar skull, the foliage and florals have been colored in vibrant shades of pinks, purples, and woodland greens. Each petal and leaf has been given special attention with graduated blending to give it shape and texture. It has been sensitively colored and the colorist has given thought to each blooming flower so that it jumps off the page. The background, meanwhile, has been completely blacked out, with not a pencil stroke to be seen.

When you place bright colors, especially an array of them as seen here, against solid black, it has the effect of creating a vibration between the two. The colors themselves almost appear to glow in the dark with neon brightness. The solid, statement background was created using a black paint pen and gives the entire image an incredibly powerful impression. Had the skull instead been placed on white, we would be looking at a more gentle and whimsical image.

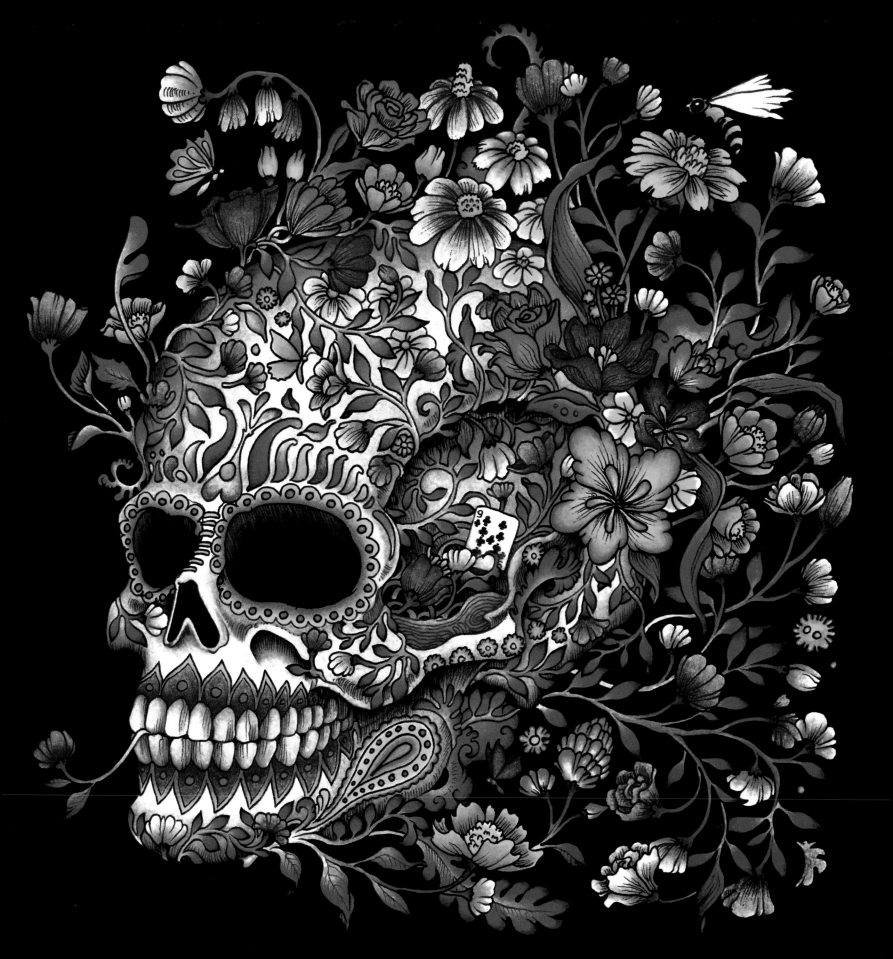

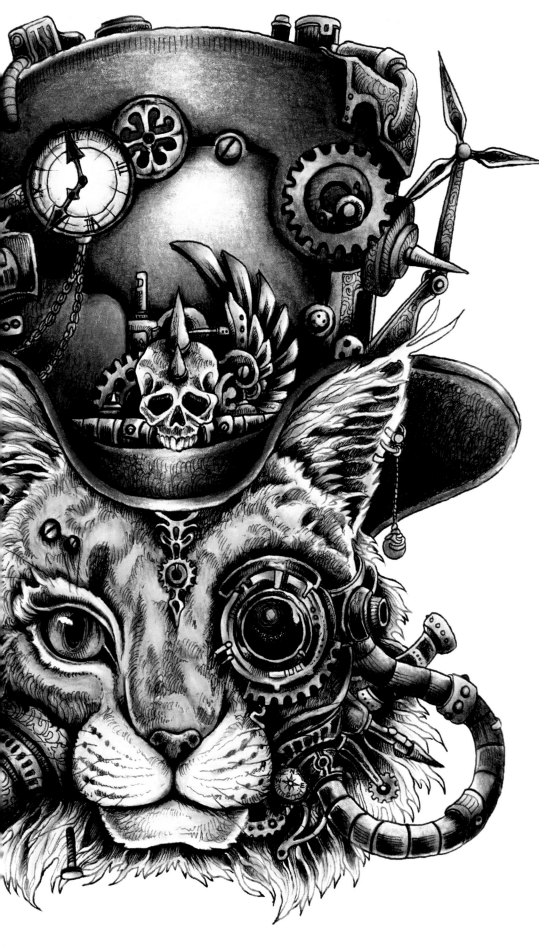

A Clockwork Cat
—The Beauty of Simplicity (this page)
Colored by Izabela Szadkowska,
a.k.a @issa_bella03

Though only two main color choices—
blues and golden oranges—have been
used for this piece, it is nevertheless
vibrant and rich with the different tonal
qualities of these shades. Blue and
orange sit opposite each other on the
color wheel and so are complementary
to one another. This means that they have
the effect of creating a vibrant contrast.
If the colorist had chosen only blues
and purples, for example, the effect would
not be so striking.

This image is also an excellent
example of how very slight tonal
shifts can suggest completely different
surfaces and textures. By adding dashes
of red and hot oranges, she has created
the fiery, glossy fur of a ginger cat. By
making use of yellows and umber, with
skillful graduated blending, she has given
the mechanical, metallic elements on
the page an authentic, brassy glow. This
picture is evidence that you don't need
hundreds of colors to create stunning
results; a limited number of colors can
be skillfully manipulated to achieve the
desired effect.

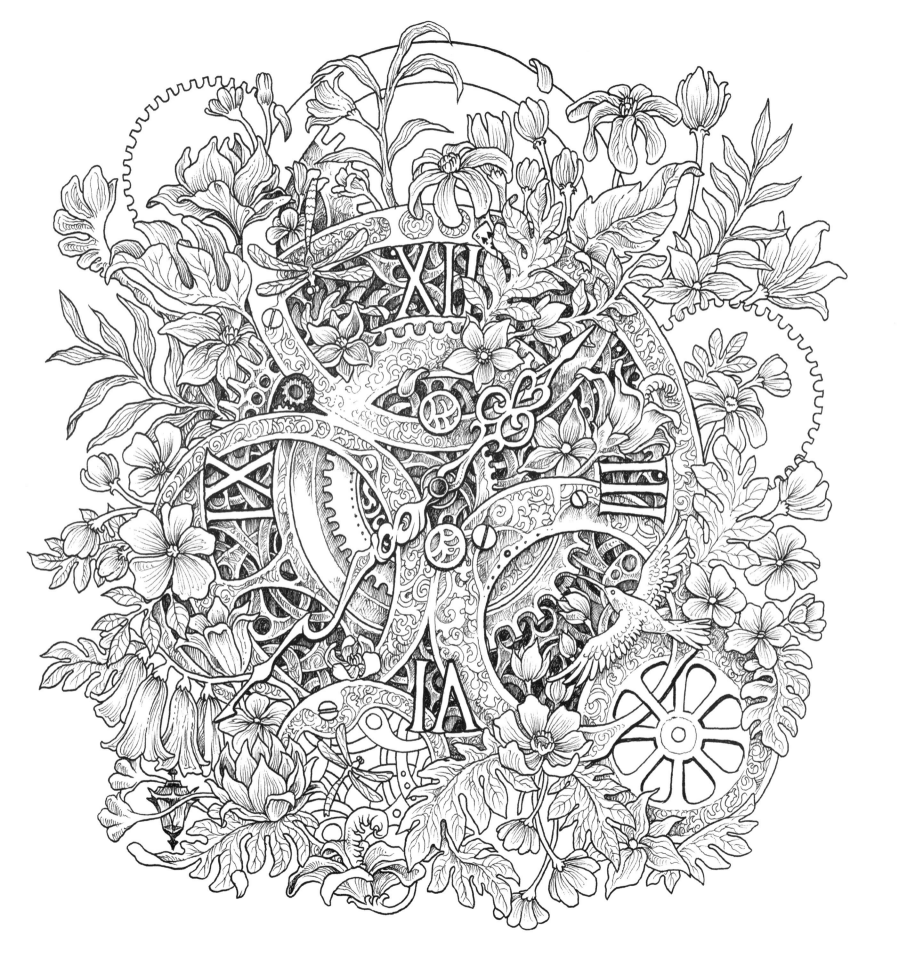

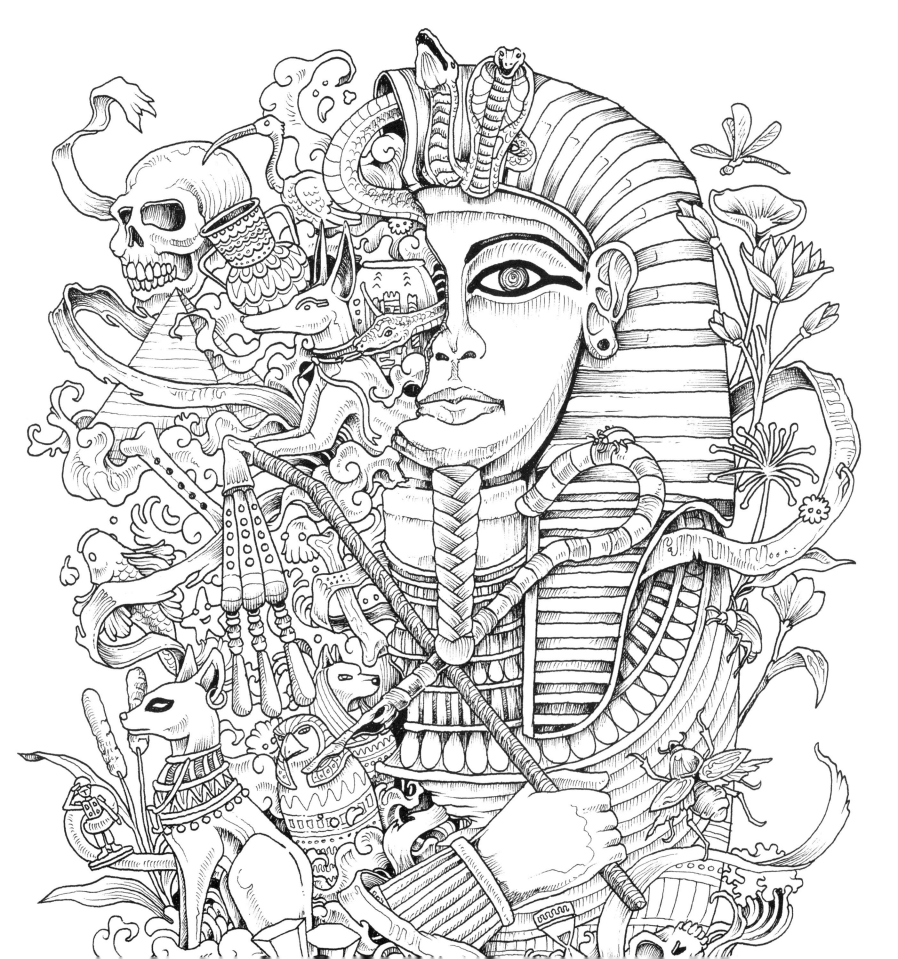

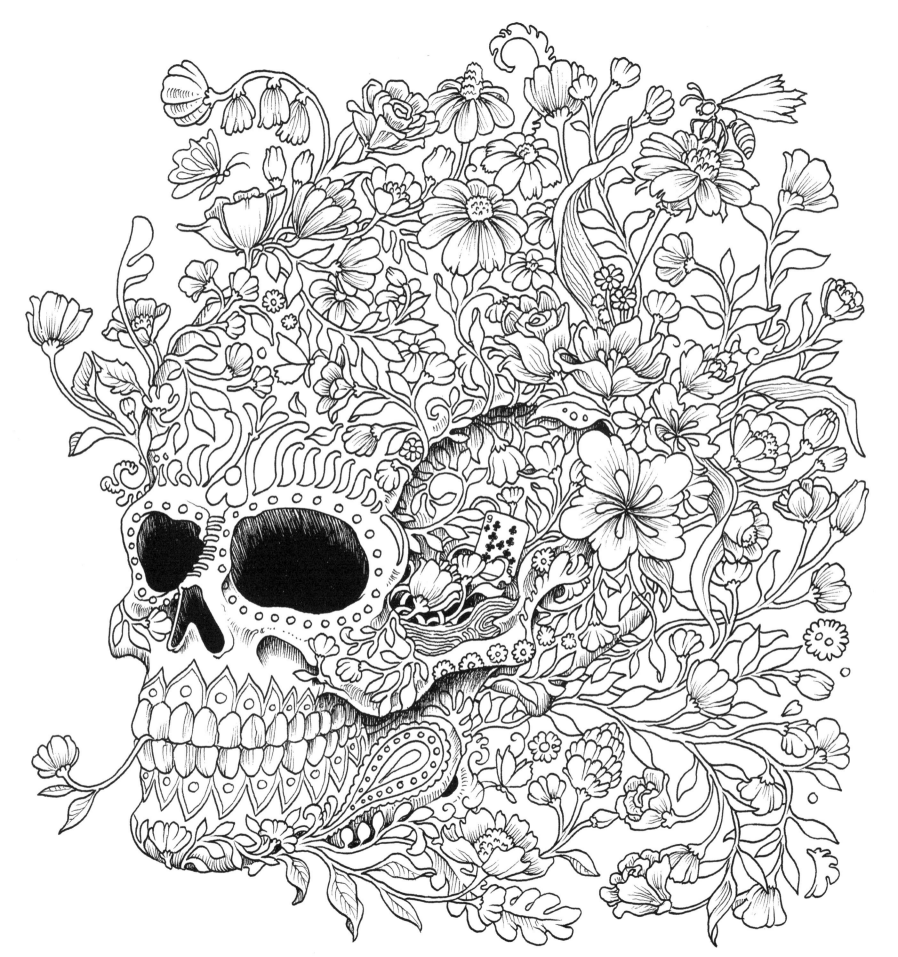

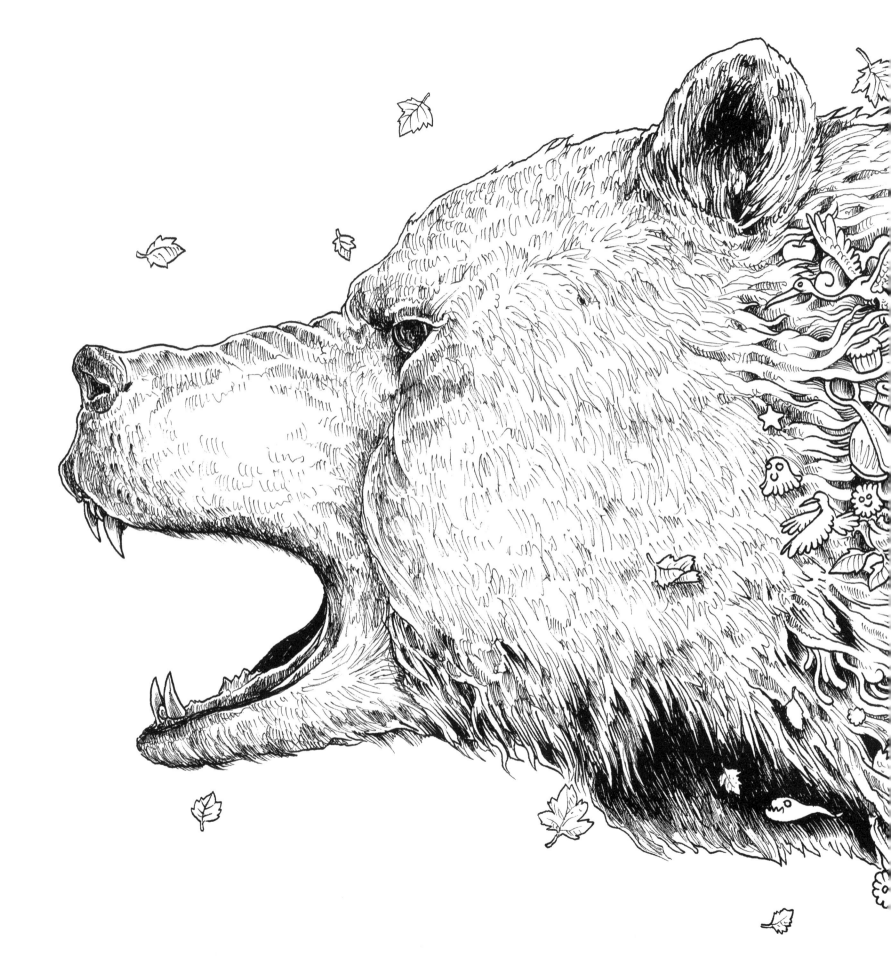

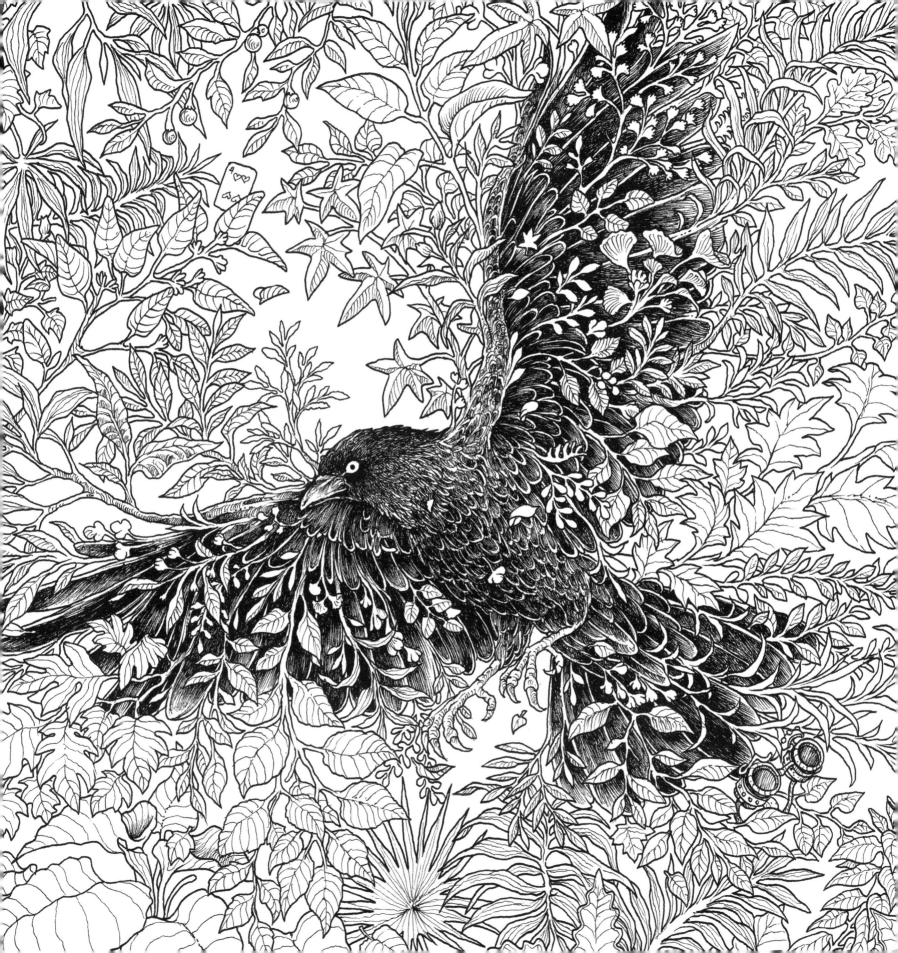

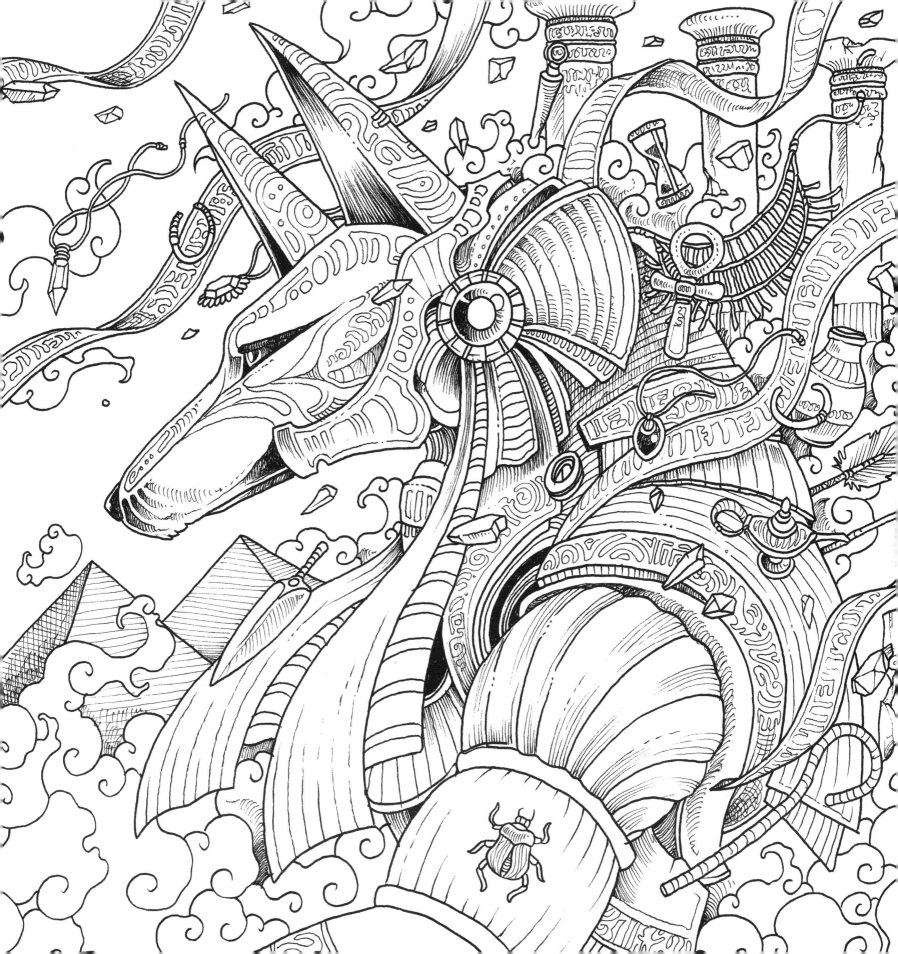

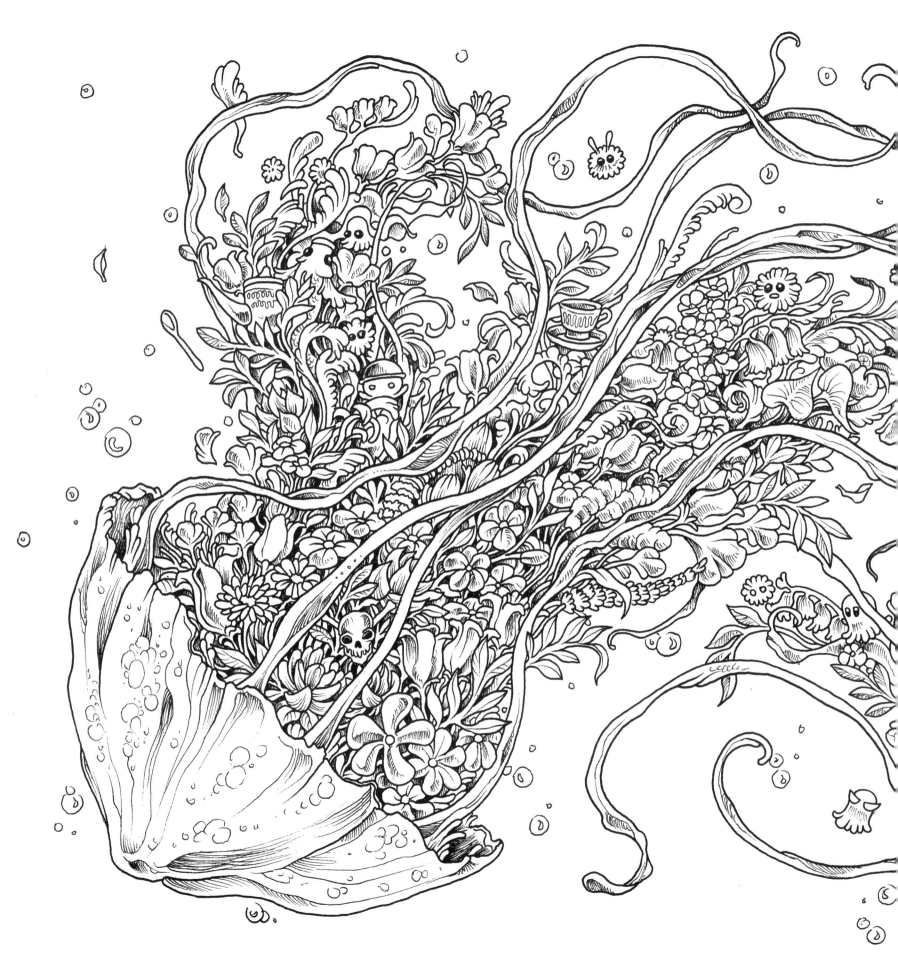

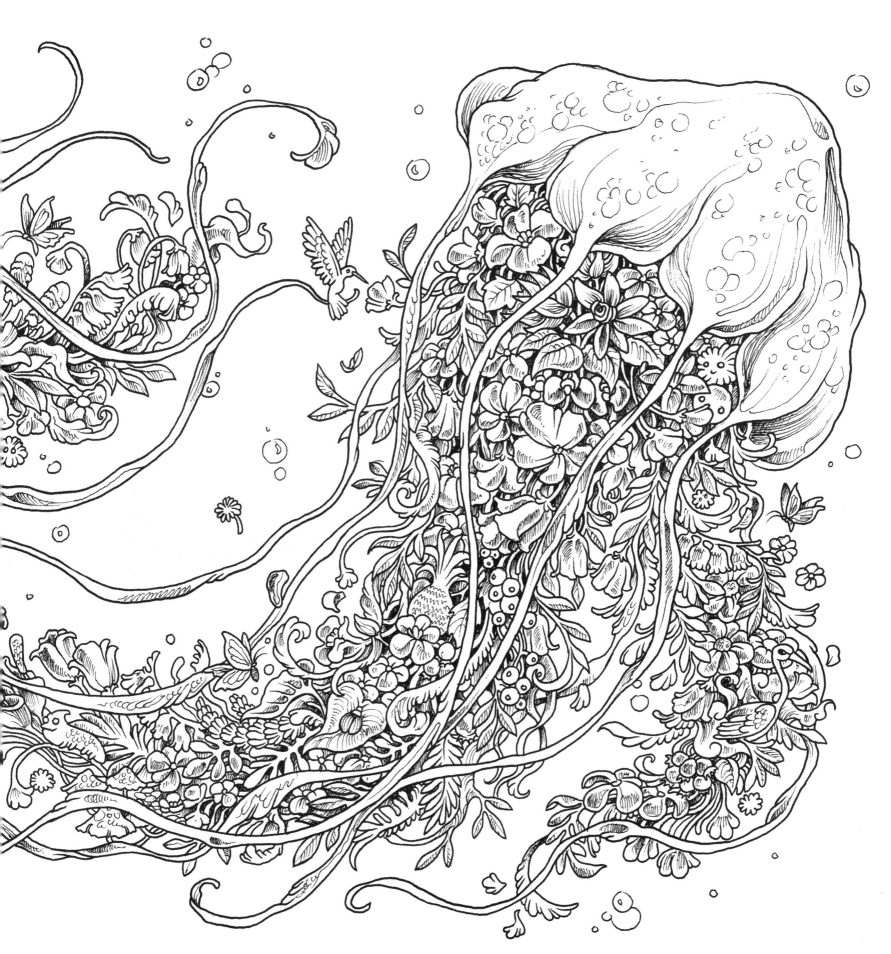

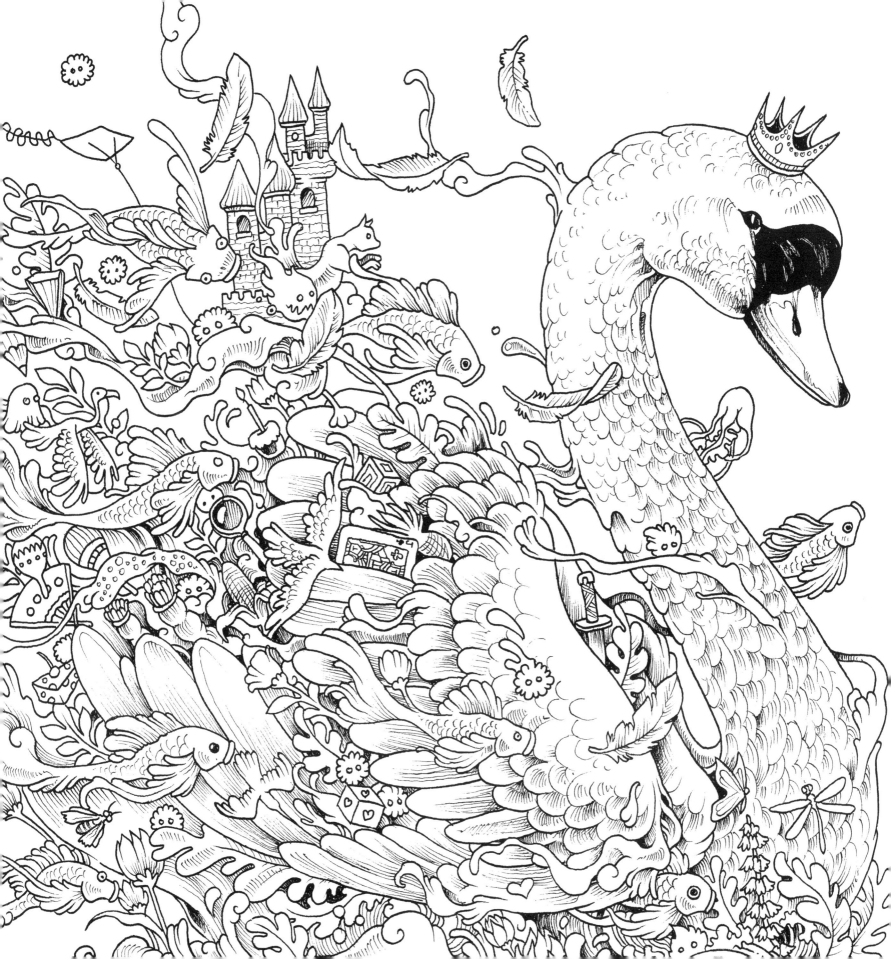

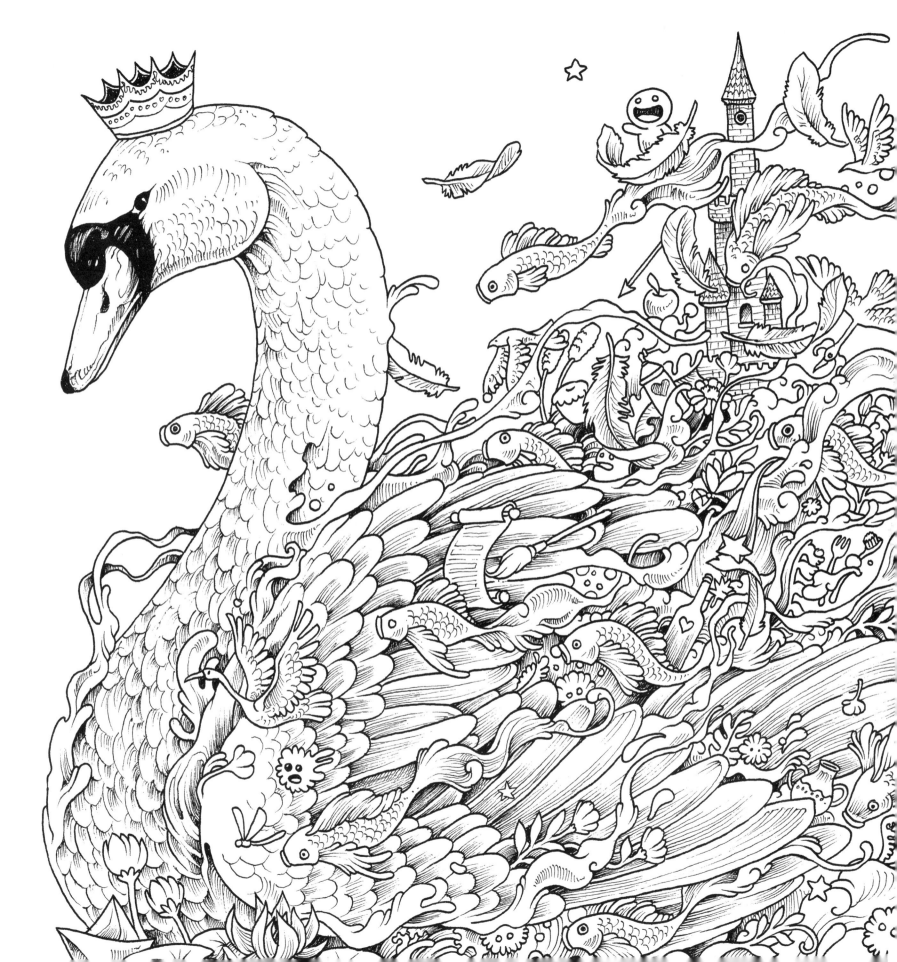

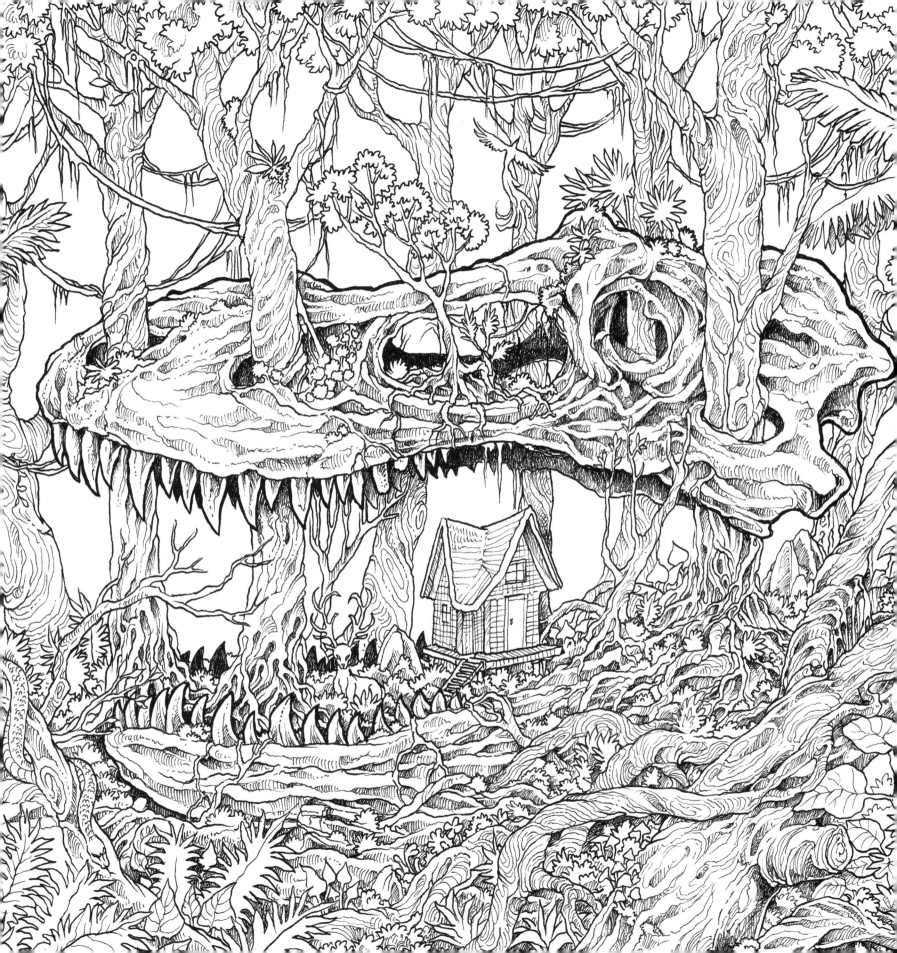

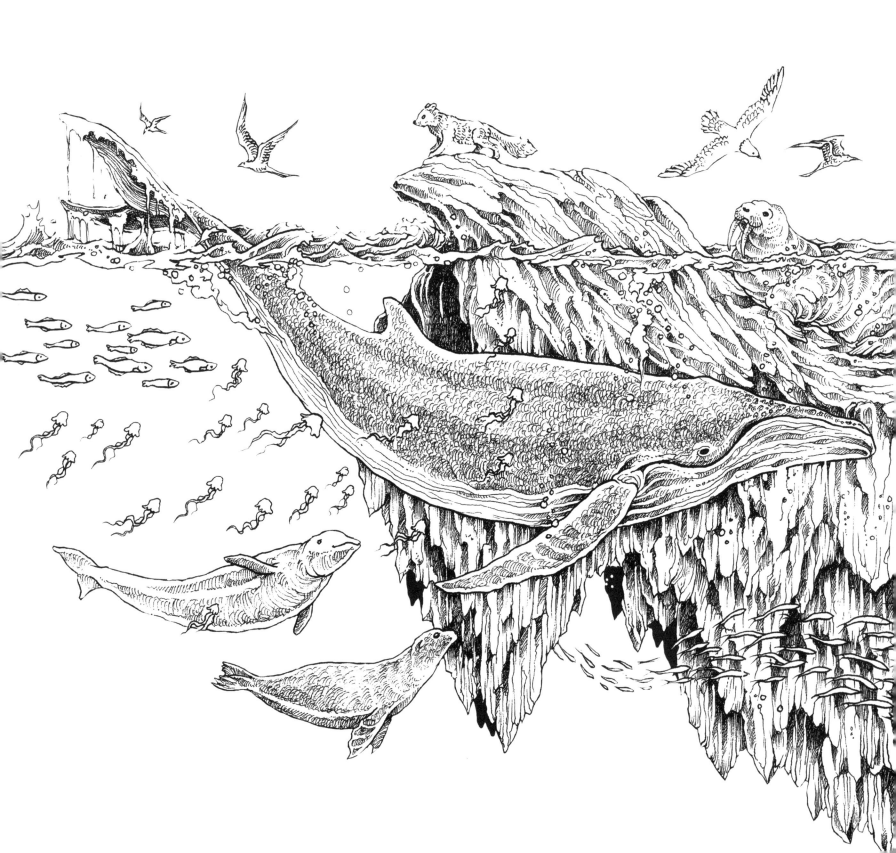

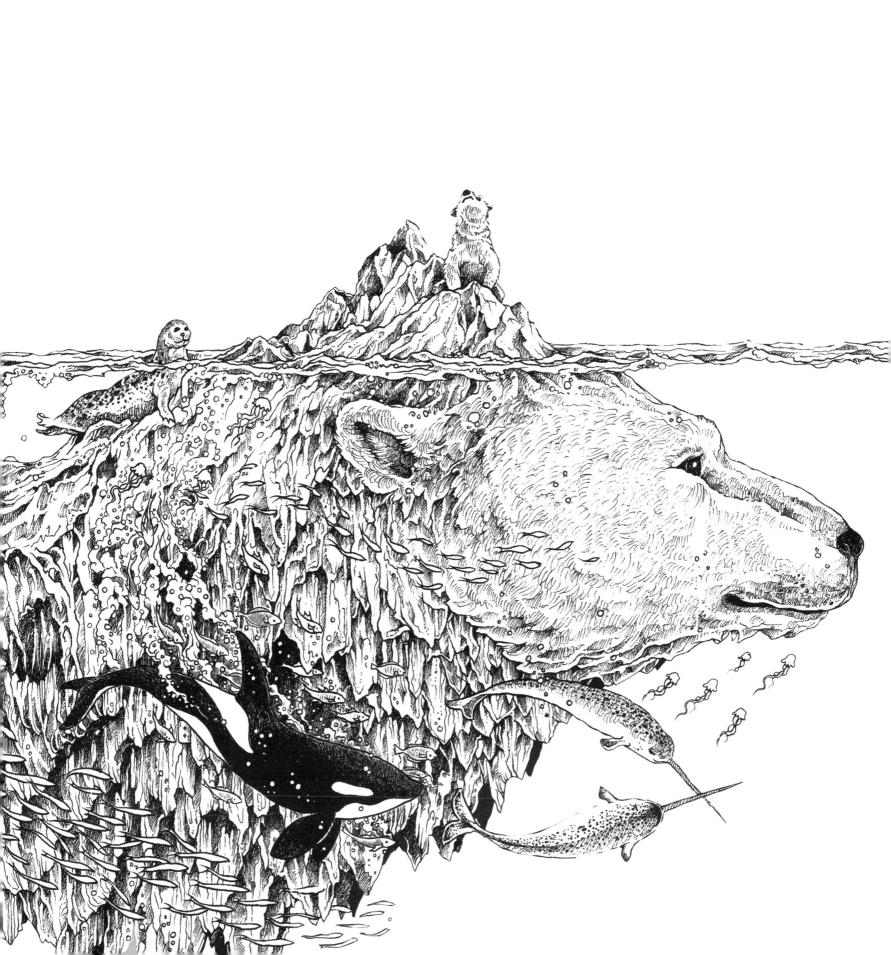

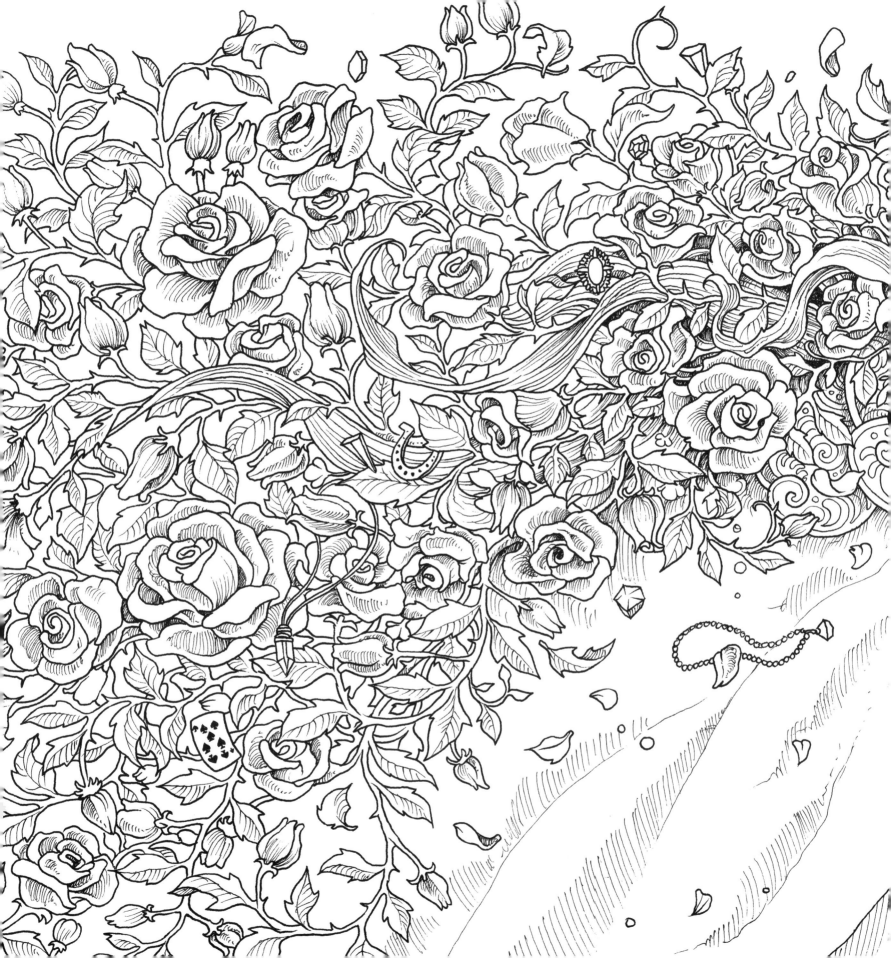

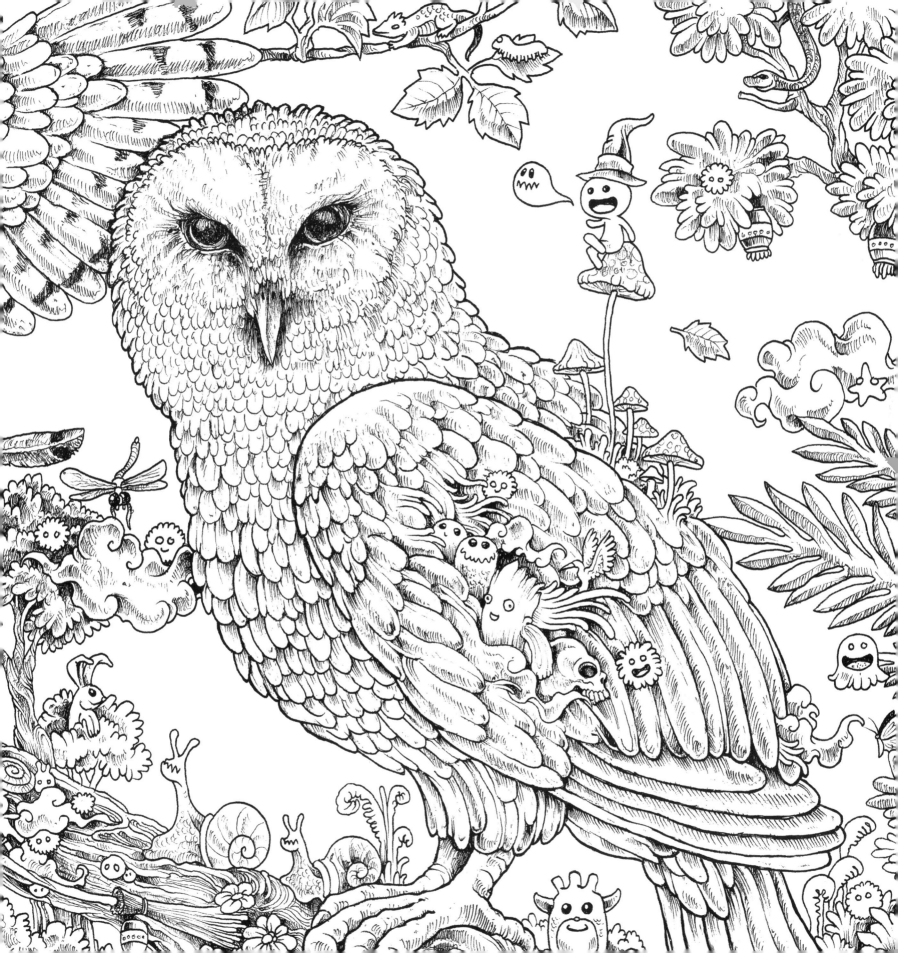

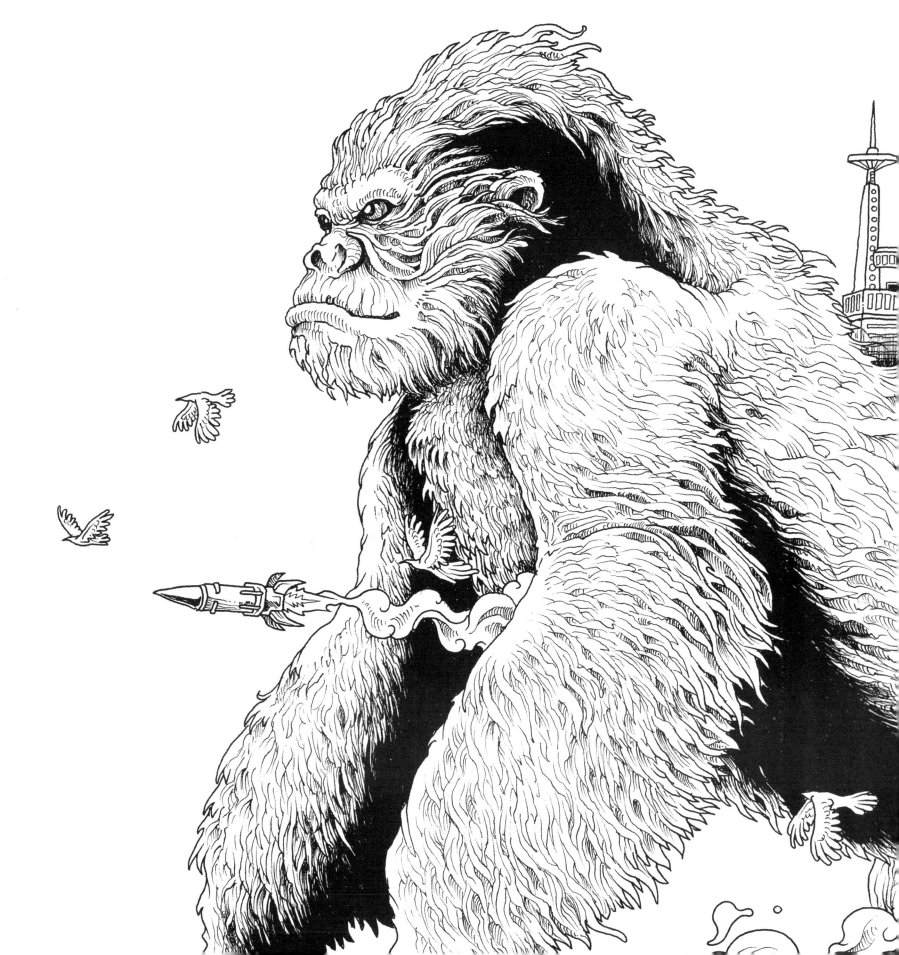

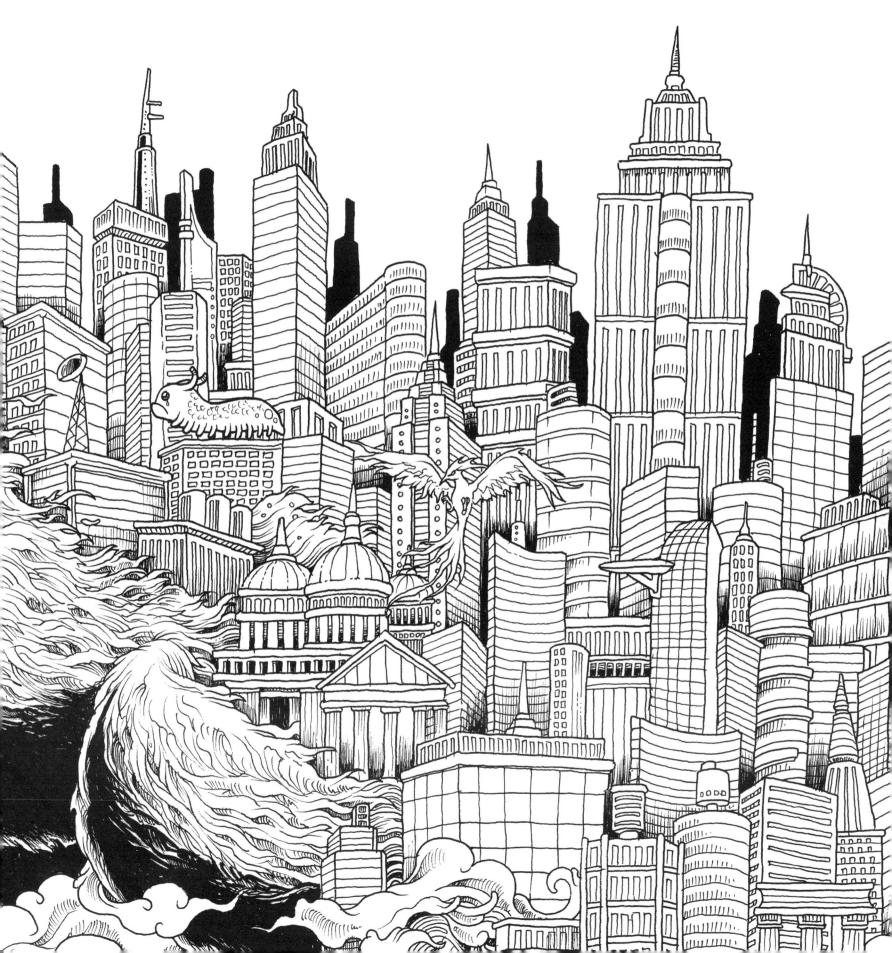

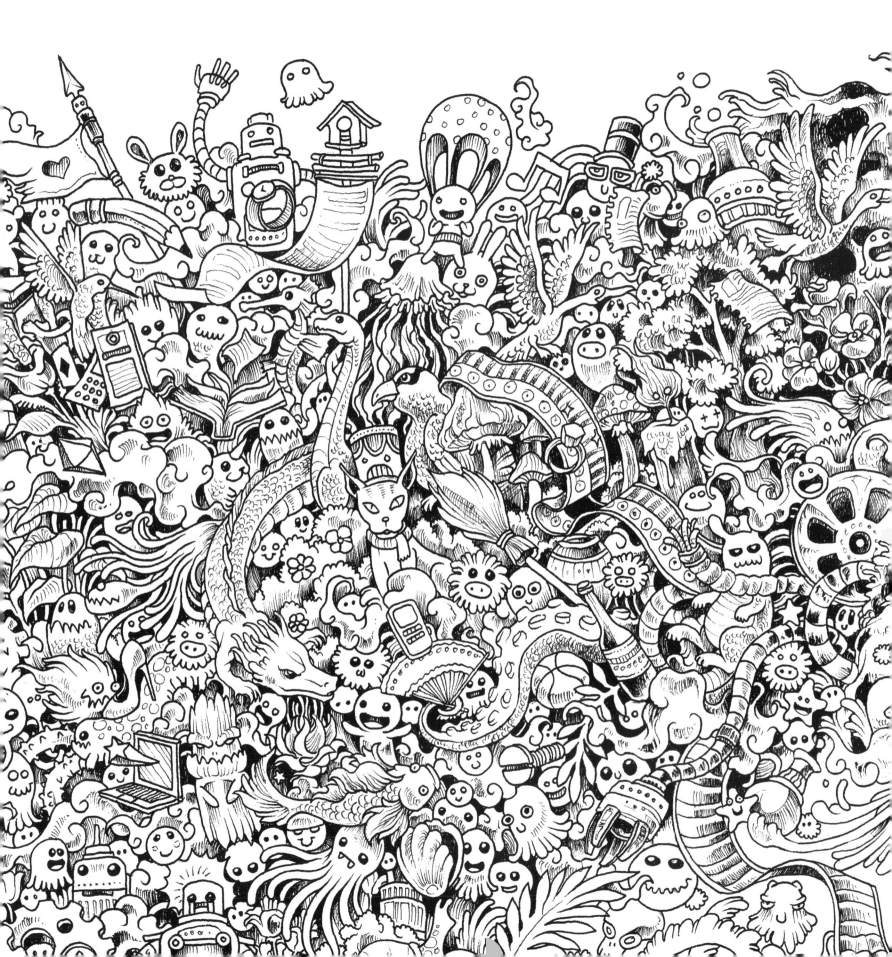

Illustrated by Kerby Rosanes
Edited by Katy Lennon
Designed by Derrian Bradder

Cover designed by Derrian Bradder
Cover images colored by Marcela Lašáková and Izabela Szadkowska

With special thanks to Lauren Farnsworth and Harry Thornton

PLUME

PENGUINRANDOMHOUSE.COM

First published in Great Britain in 2019 by
LOM ART, an imprint of Michael O'Mara Books Limited,
9 Lion Yard, Tremadoc Road, London SW4 7NQ

W mombooks.com/lom f Michael O'Mara Books OMaraBooks lomartbooks

ISBN 9780593083789

Printed in the United States of America
10th Printing